Here is the memory of what you are.
Written and photographed by James Spicer

GALLERY HIDDEN PRESS

Chicago

Copyright ©2007 James Spicer

All rights reserved which includes the right to reproduce this book or portions thereof in any form whatsoever. For contact information visit www.galleryhidden.com.

ISBN: 978-0-6151-8009-0

Gallery Hidden Press®
Chicago

www.galleryhidden.com

When does a dream go stale?

—

It is their own dwelling place.

Everything else is your own nightmare and does not exist.

An unknown, remote, or nonexistent place.

You are a stranger here.

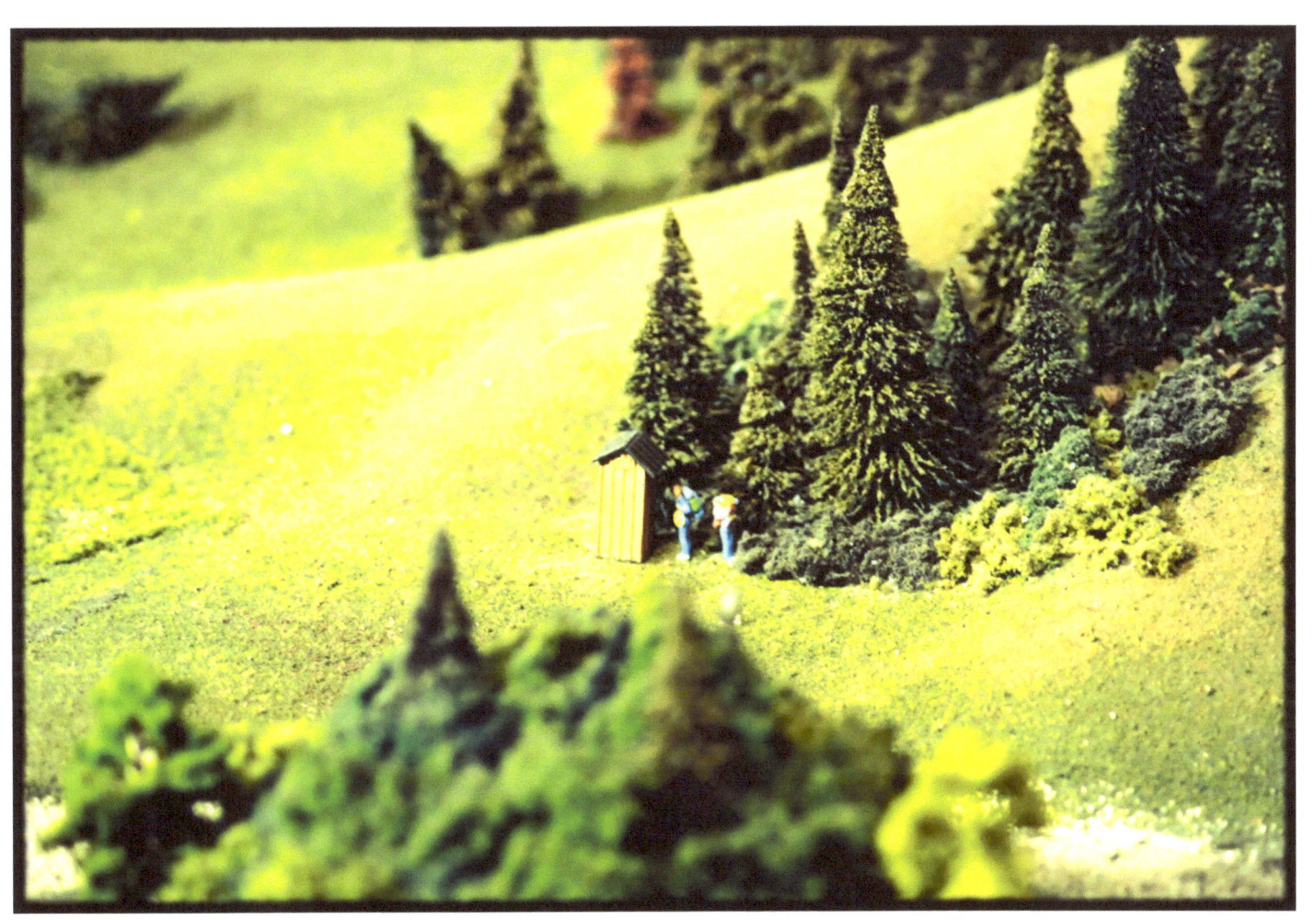

No room for intrusions.

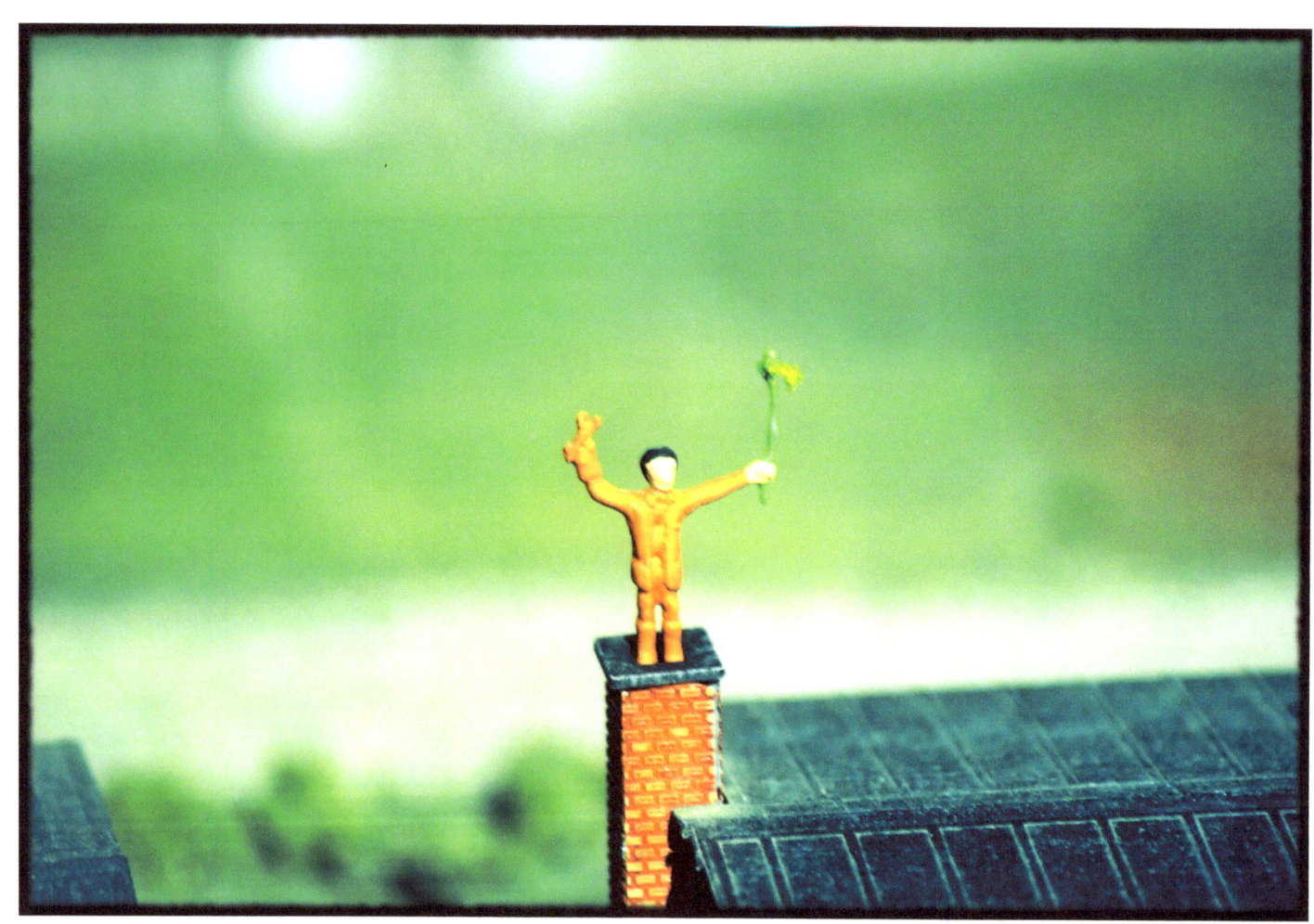

See him as he is.

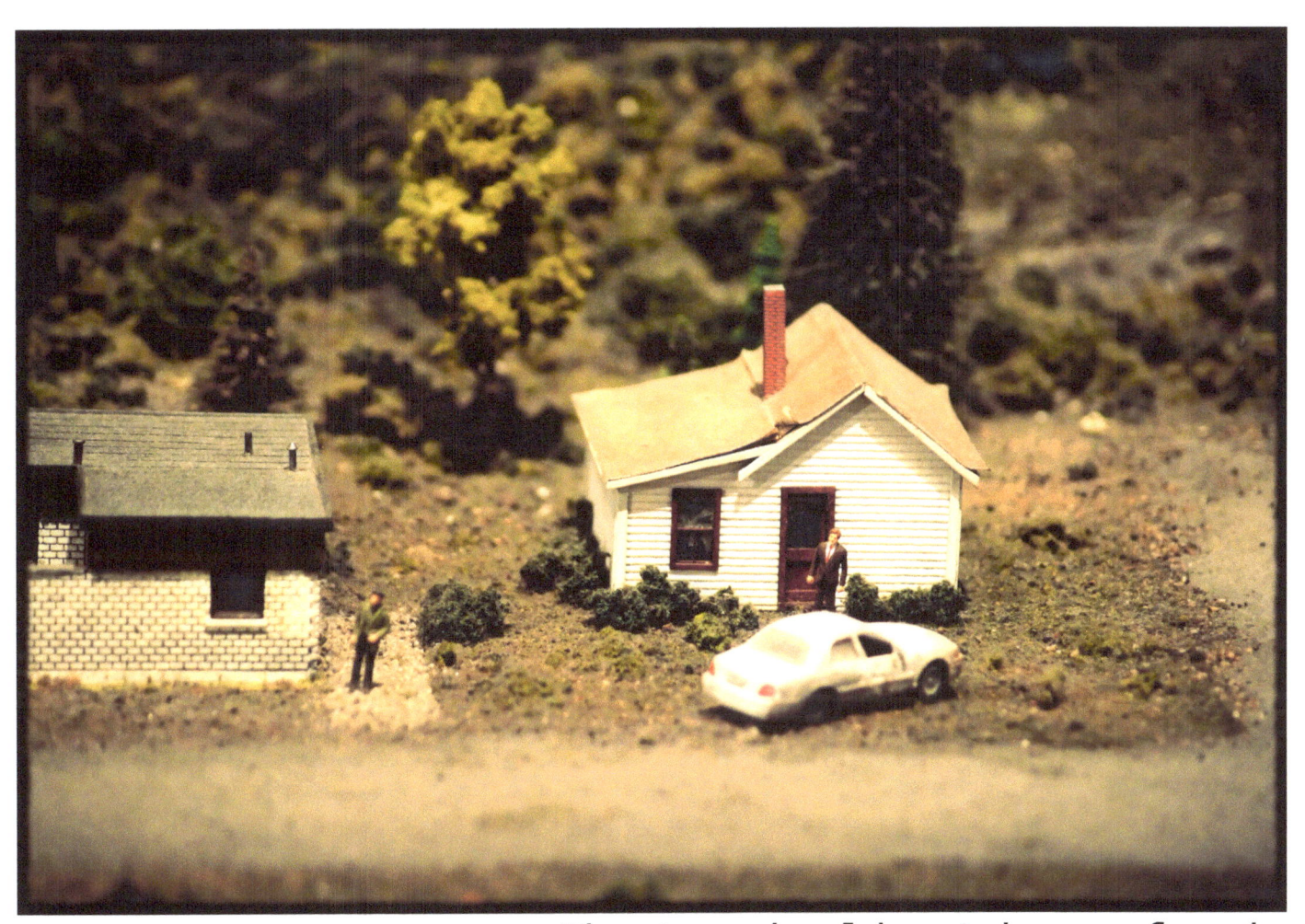

The two should not be confused.

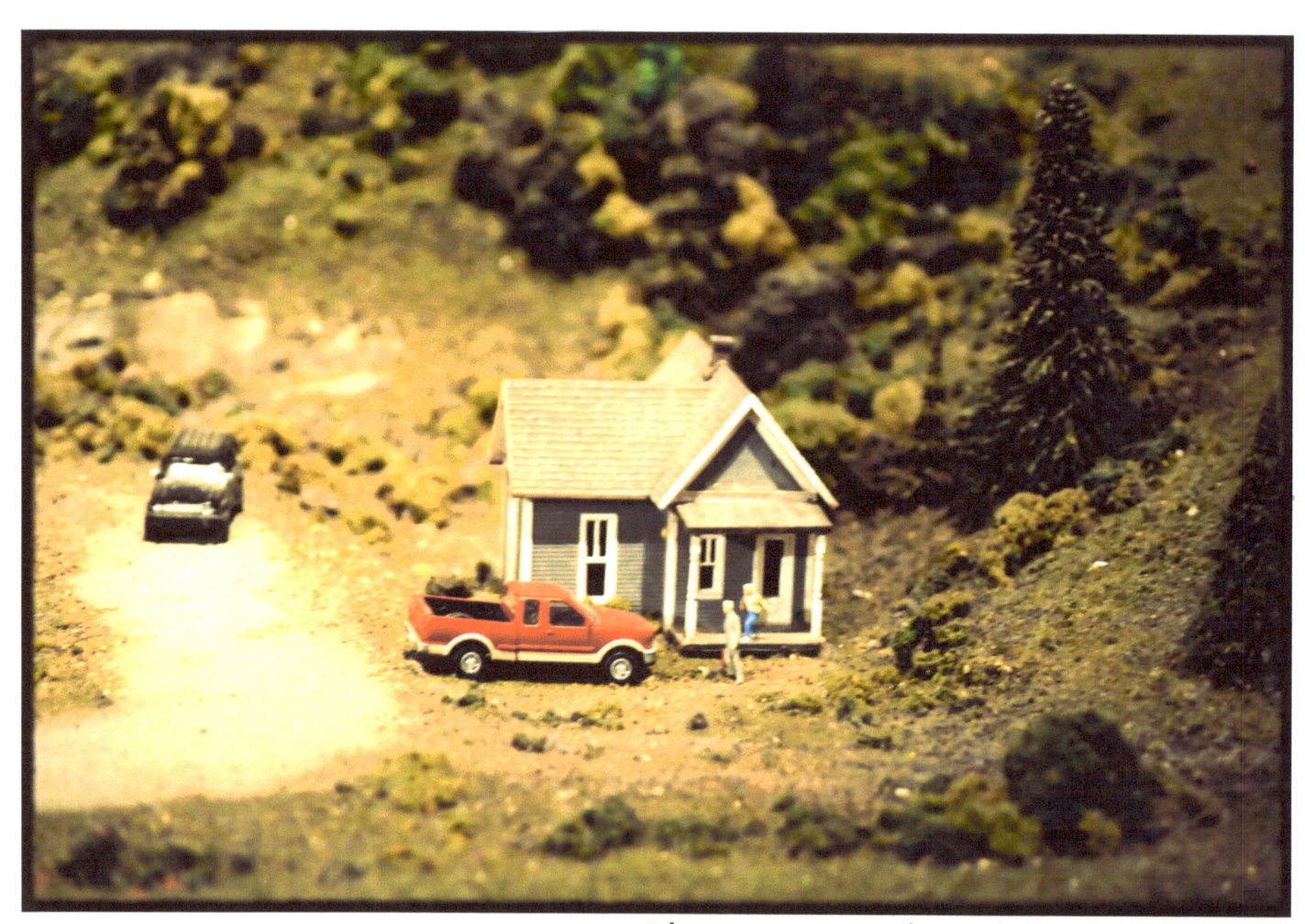

The separation has occurred.

Those who temporarily have less.

He has done something loveless.

This is how man must think of himself in his heart, because this is what he is.

An imprisoned will engenders a situation.

A feeble attempt at identification.

They believe in what they made.

They bring more love.

There is nothing else.

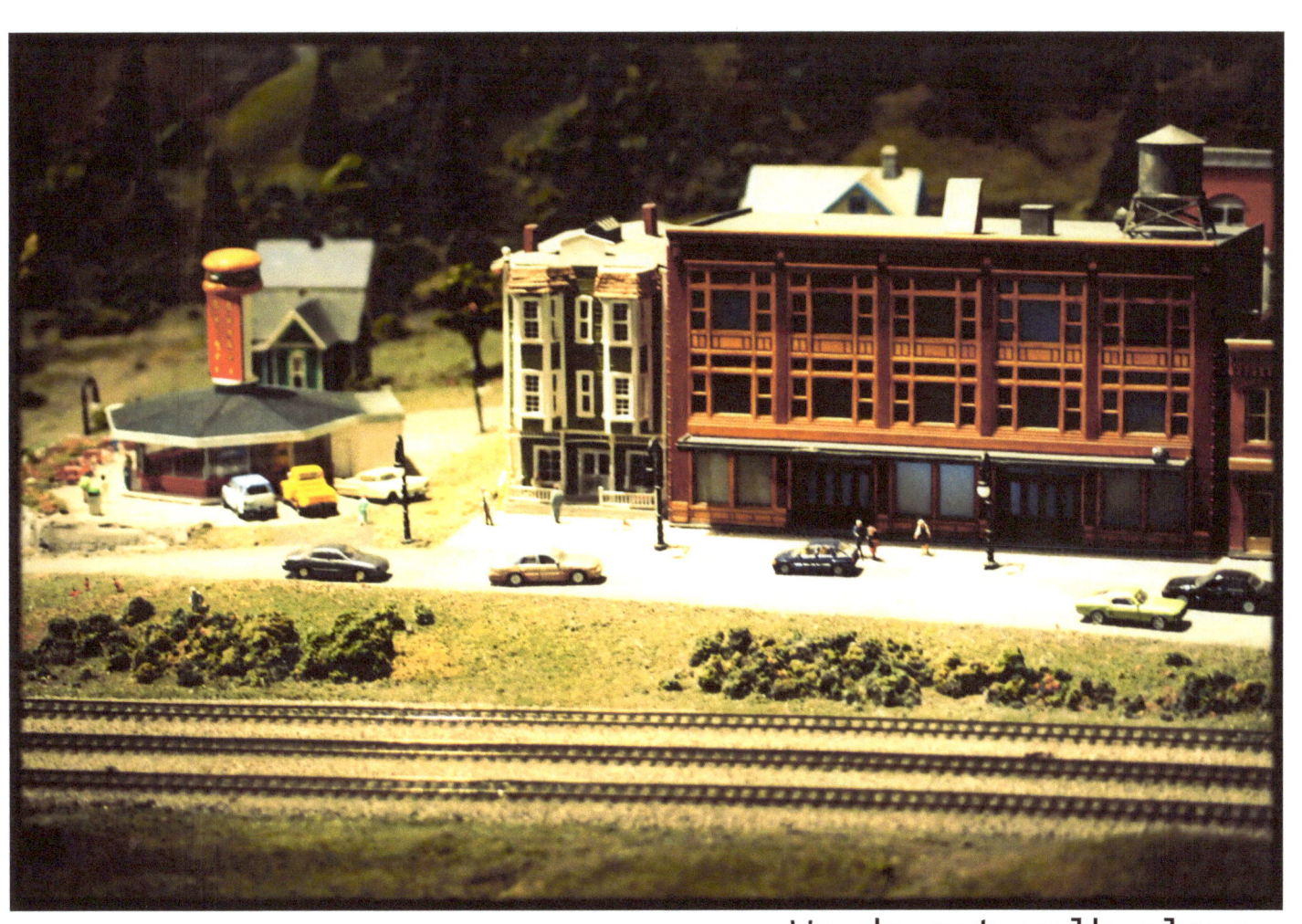

We do not walk alone.

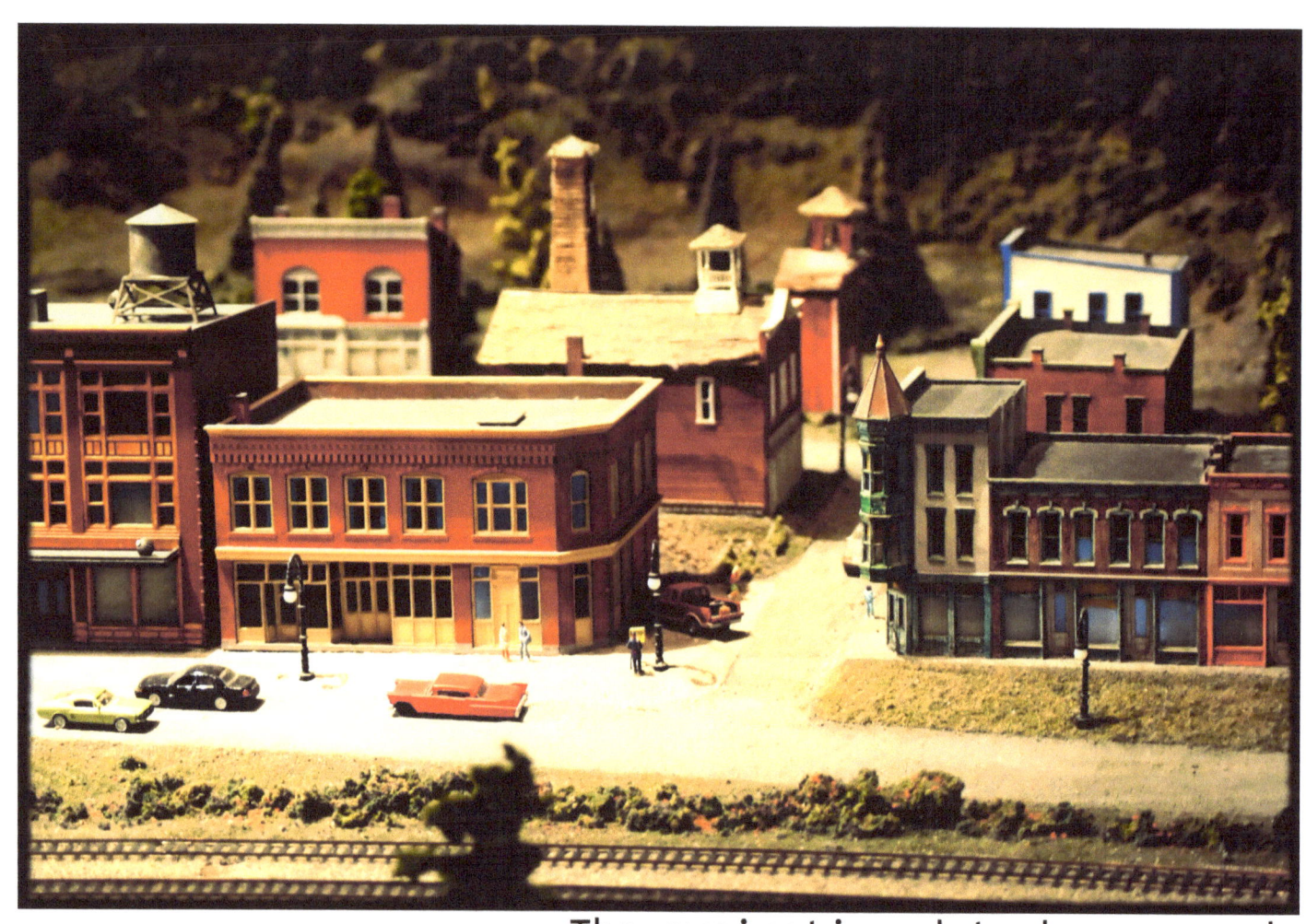

The expiration date has passed.

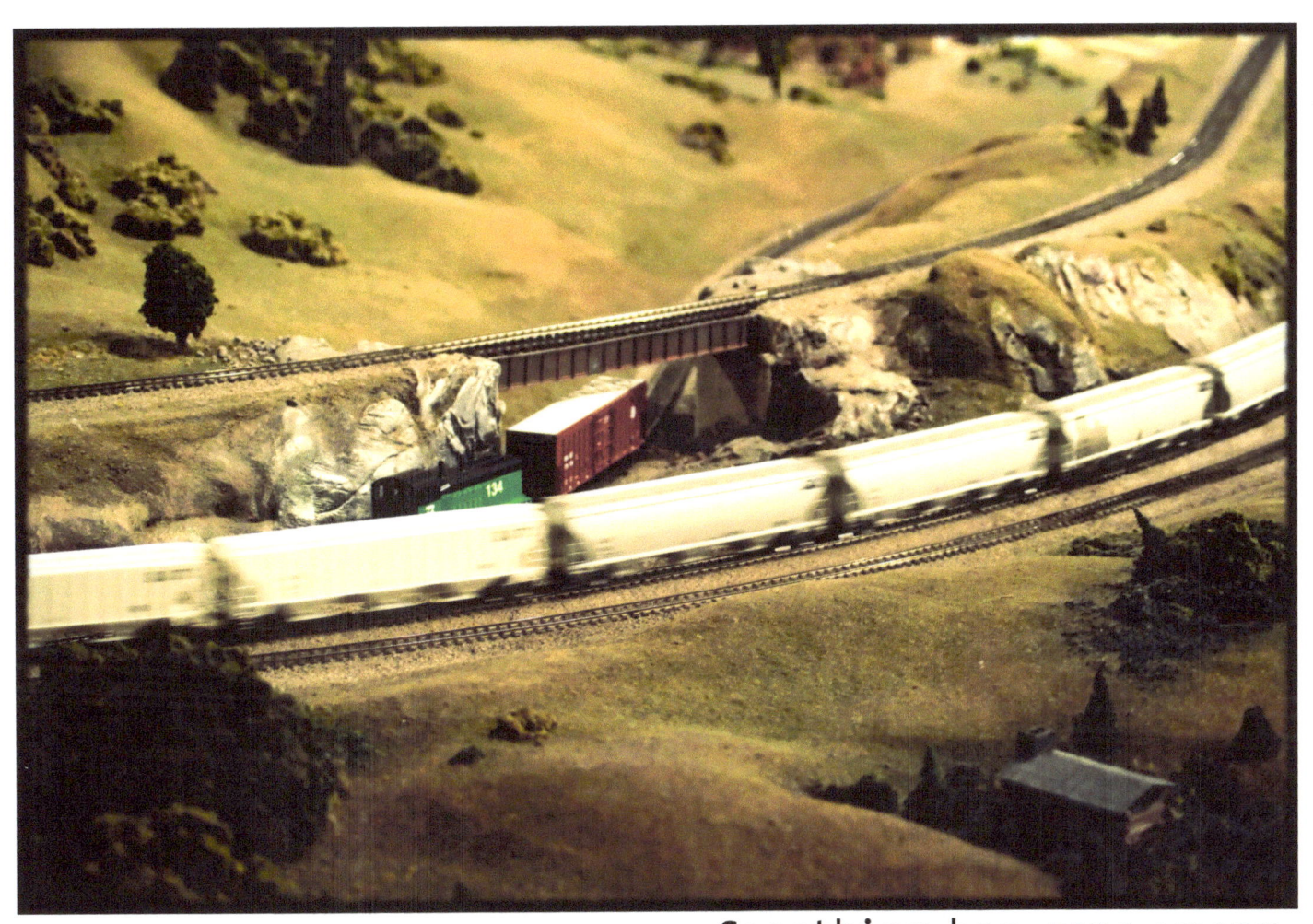

Something has gone wrong.

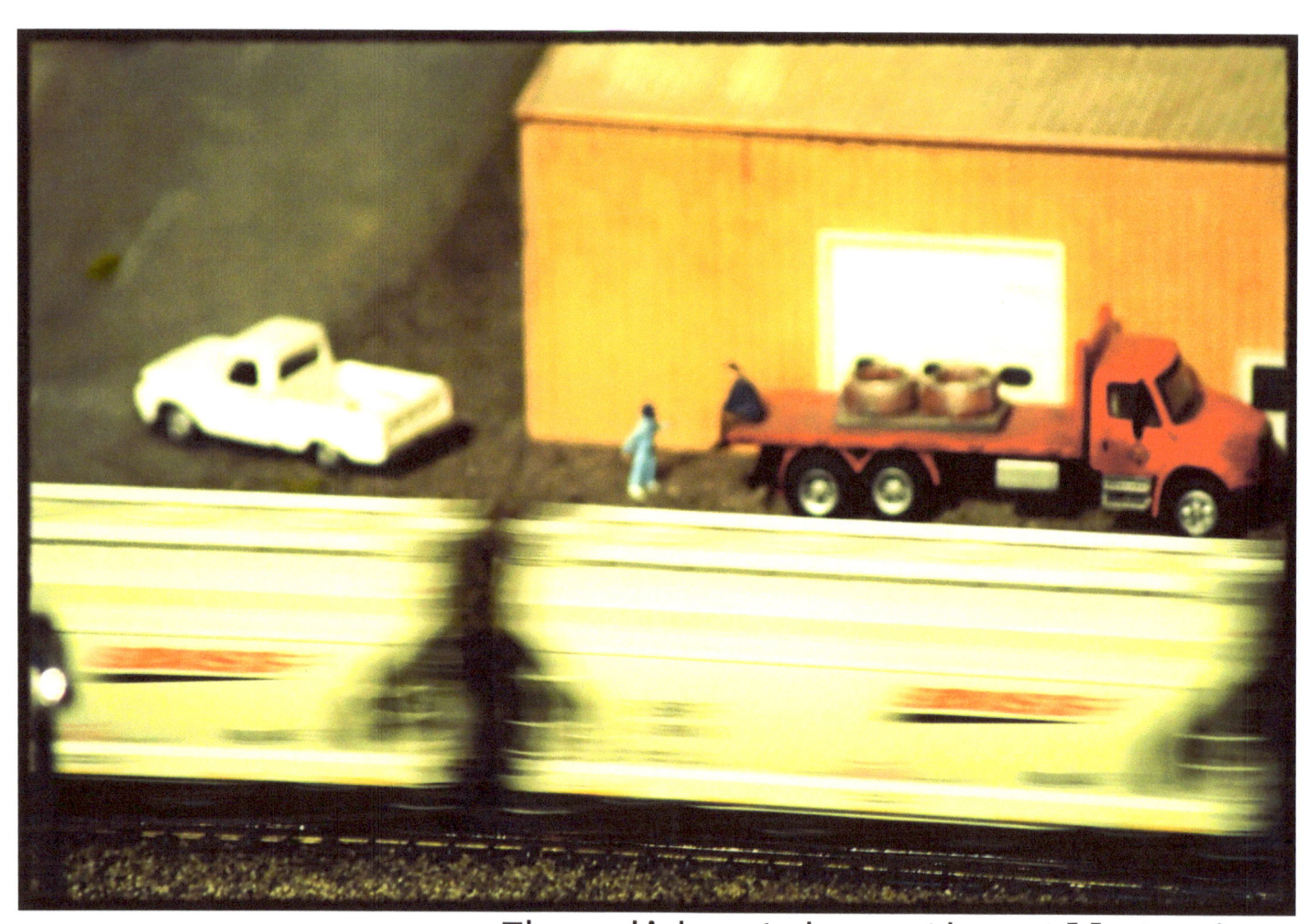

They did not hear the call to joy.

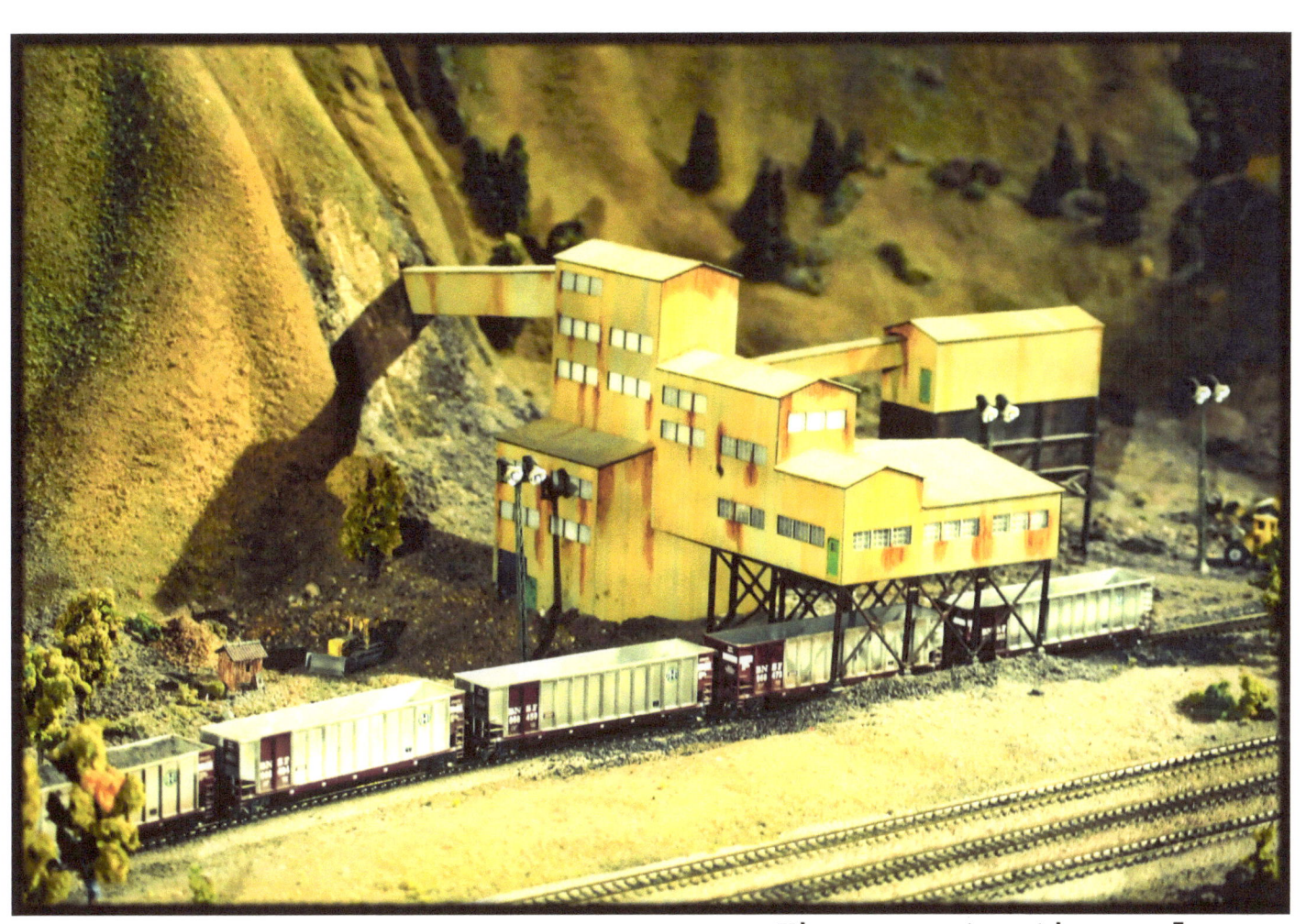

They waste themselves.

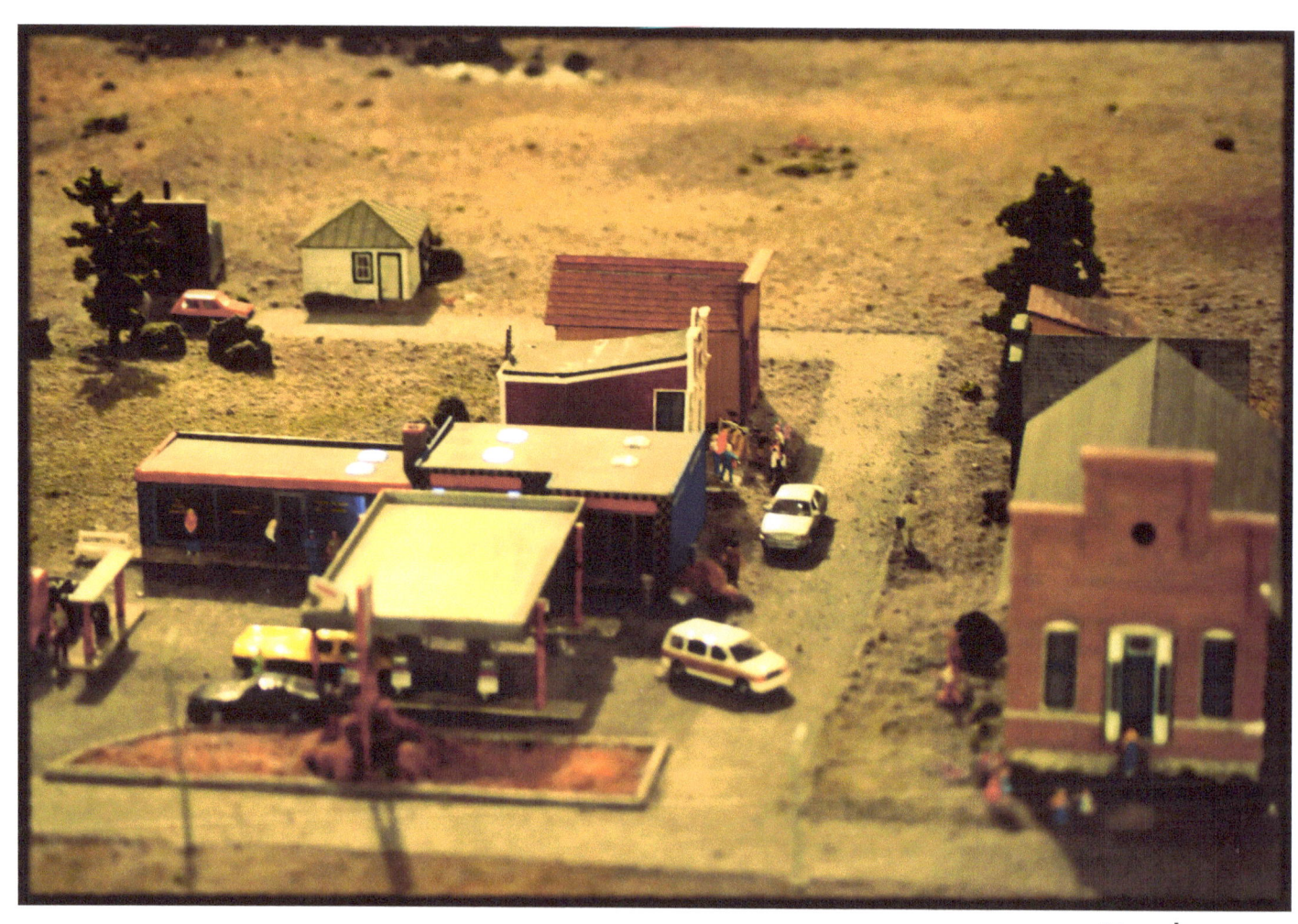

Nowhere.

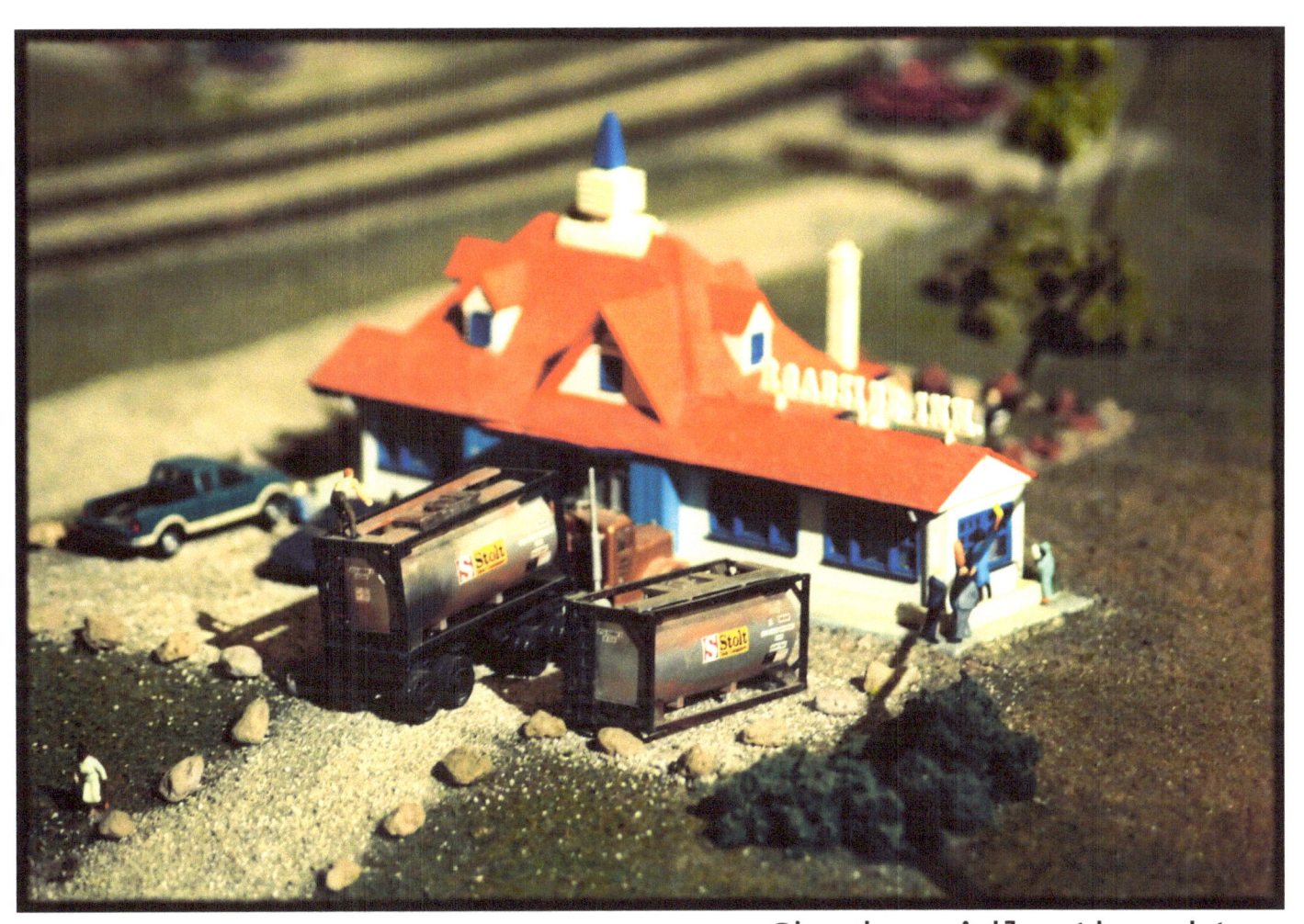

She has idle thoughts.

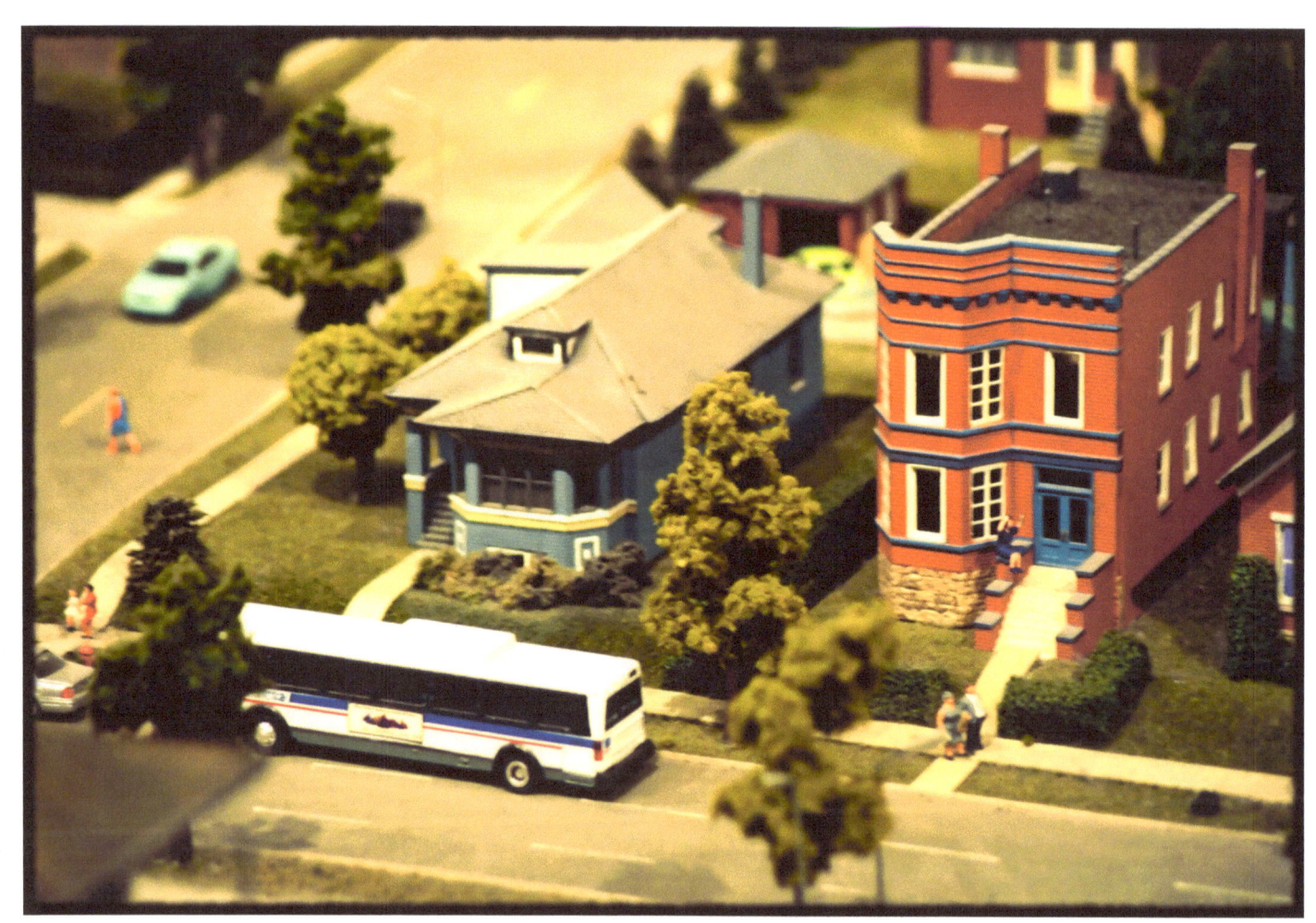
No one has been sure of anything since.

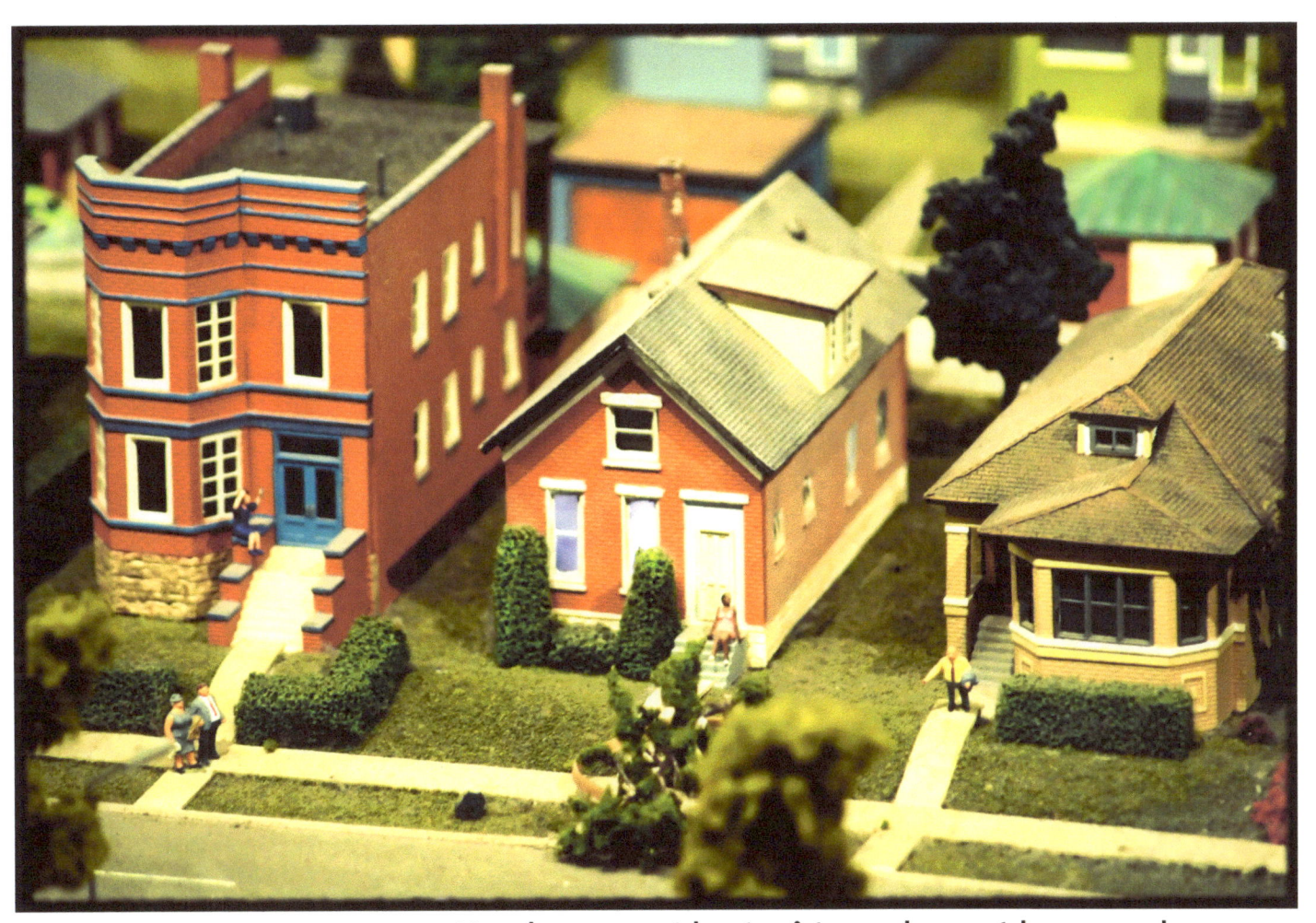

He knows that it makes them unhappy.

Spectacles to induce belief.

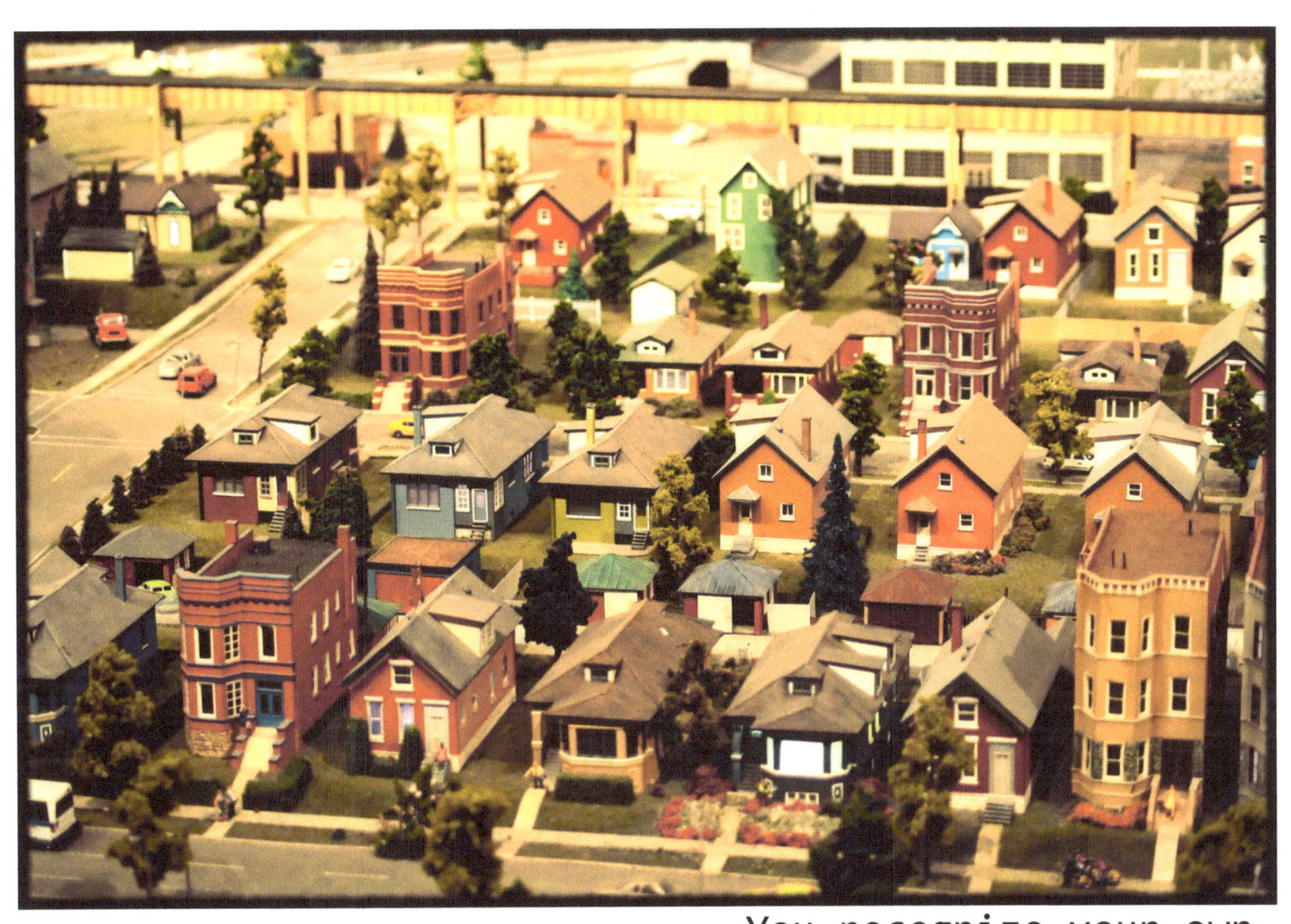

You recognize your own.

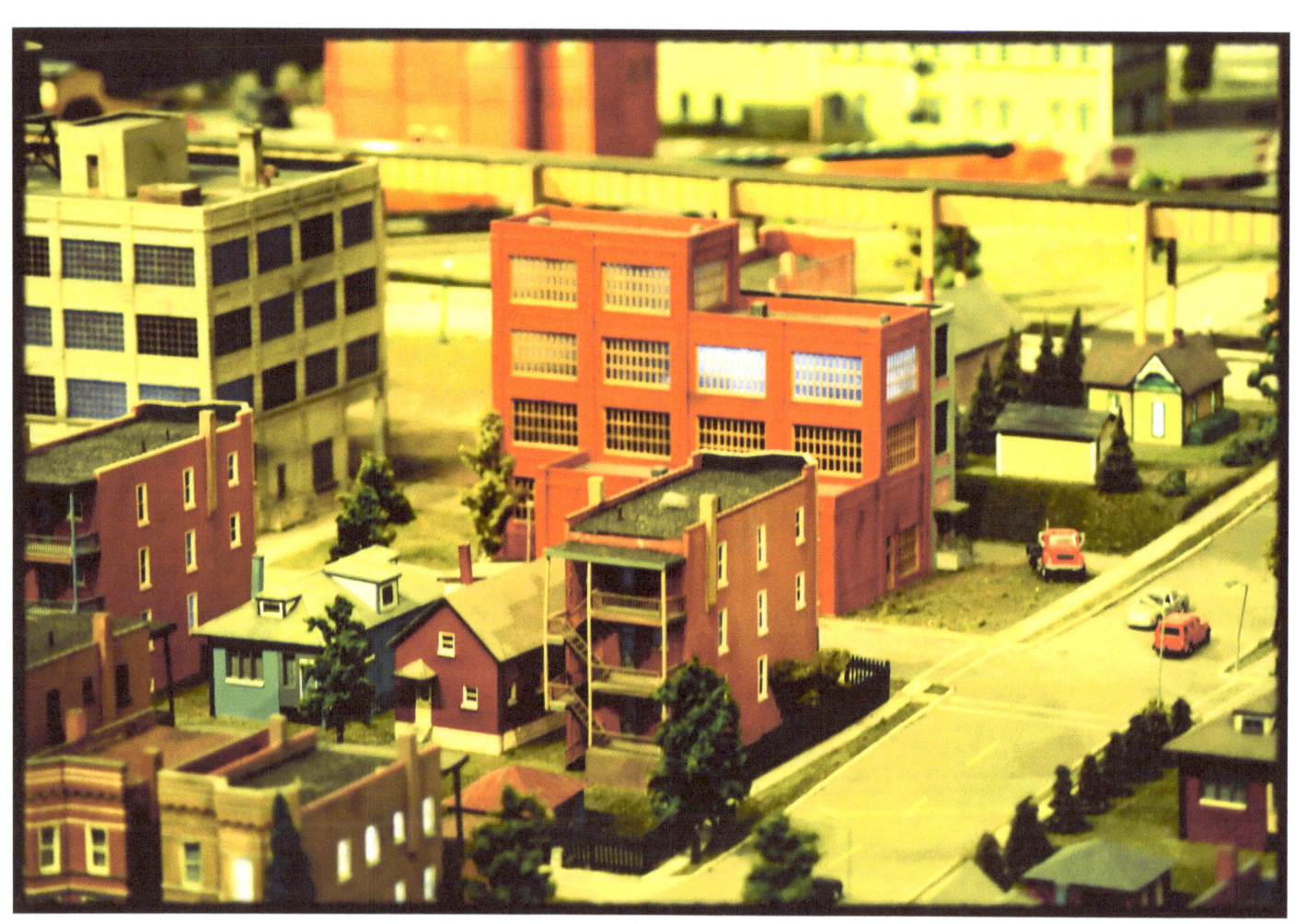

They are beautiful enough to hold it.

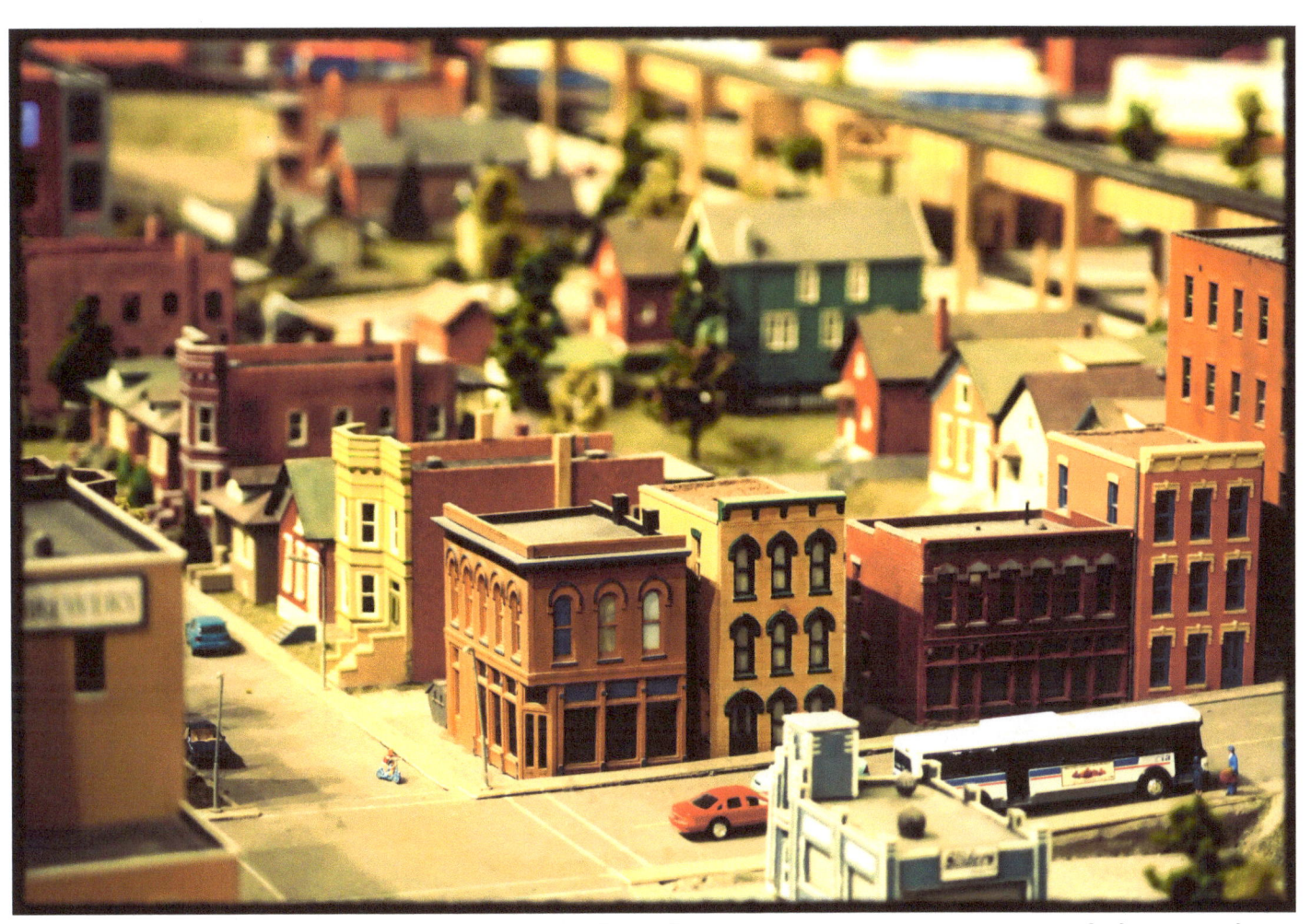

Physical closeness cannot achieve it.

In this order you are perfect.

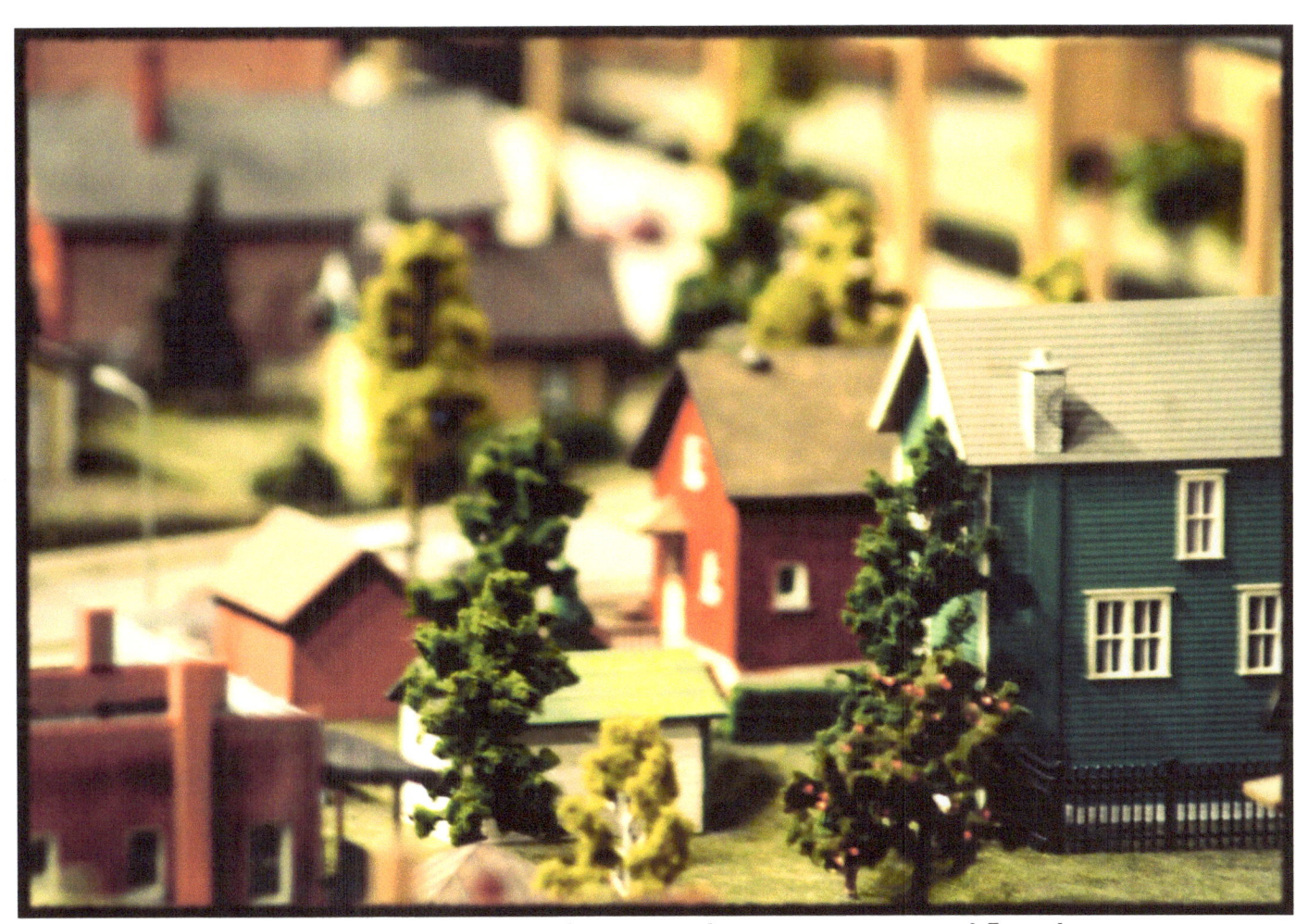

Those who temporarily have more.

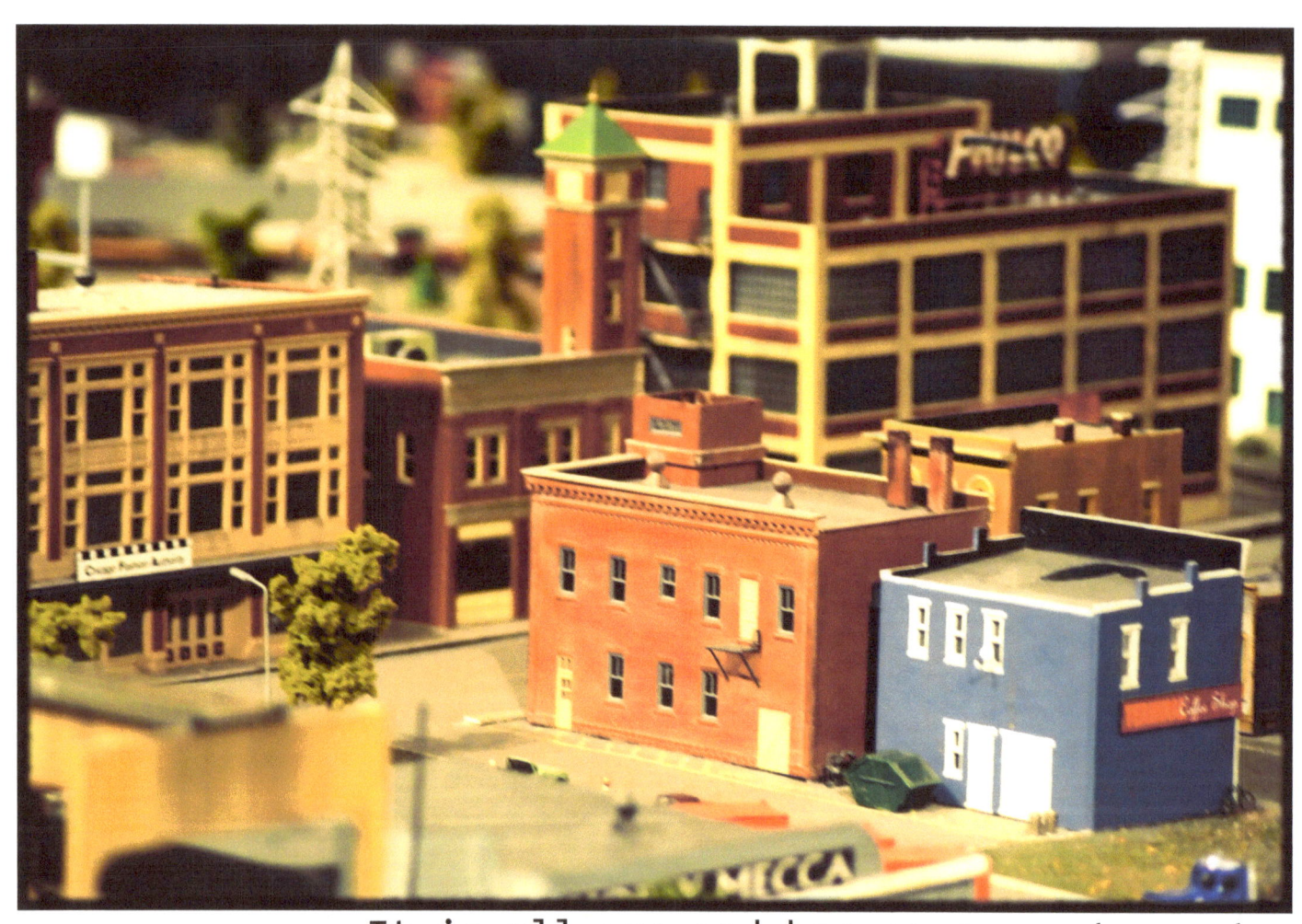
It is all one and has no separate parts.

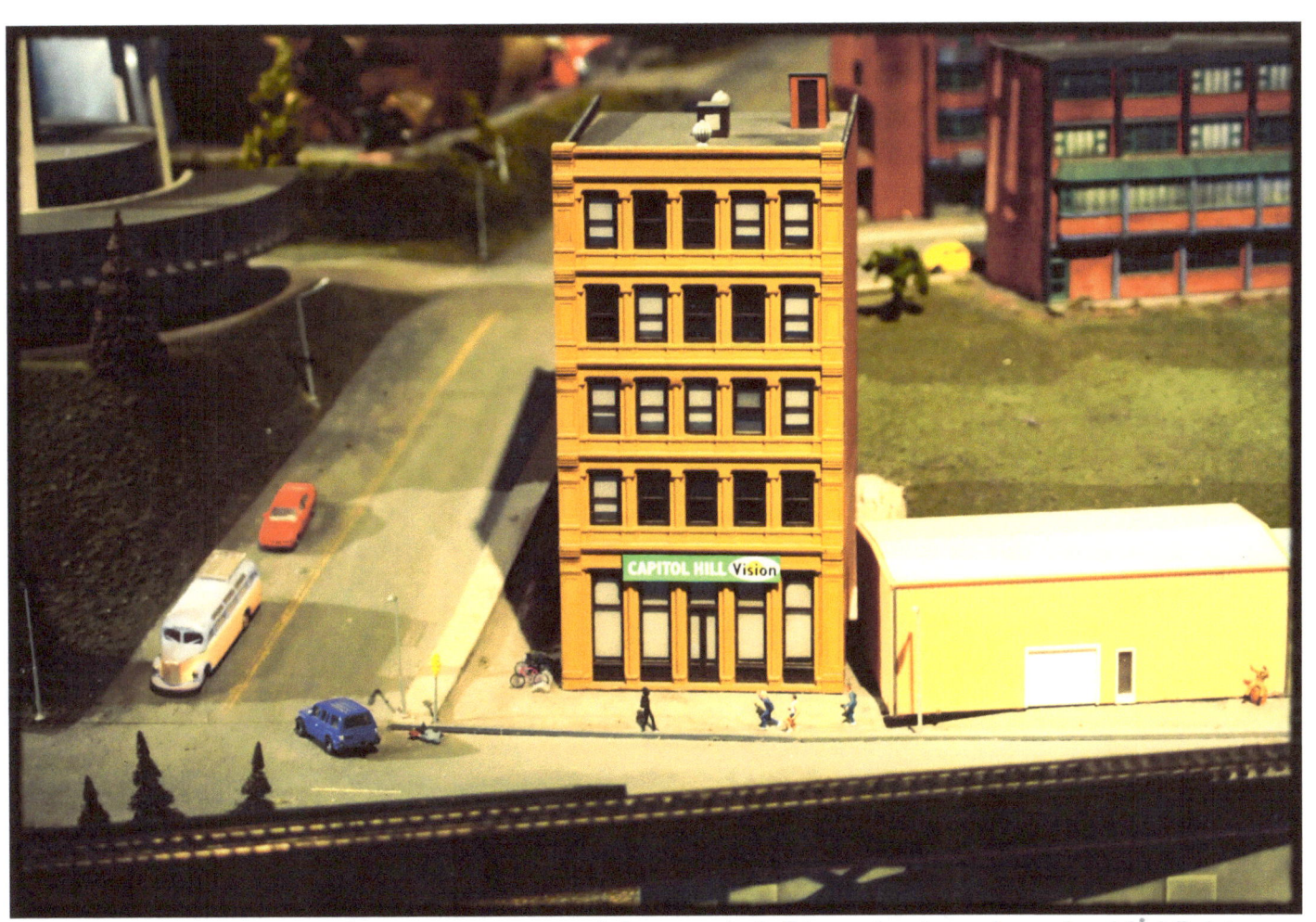

They are sudden shifts into invisibility.

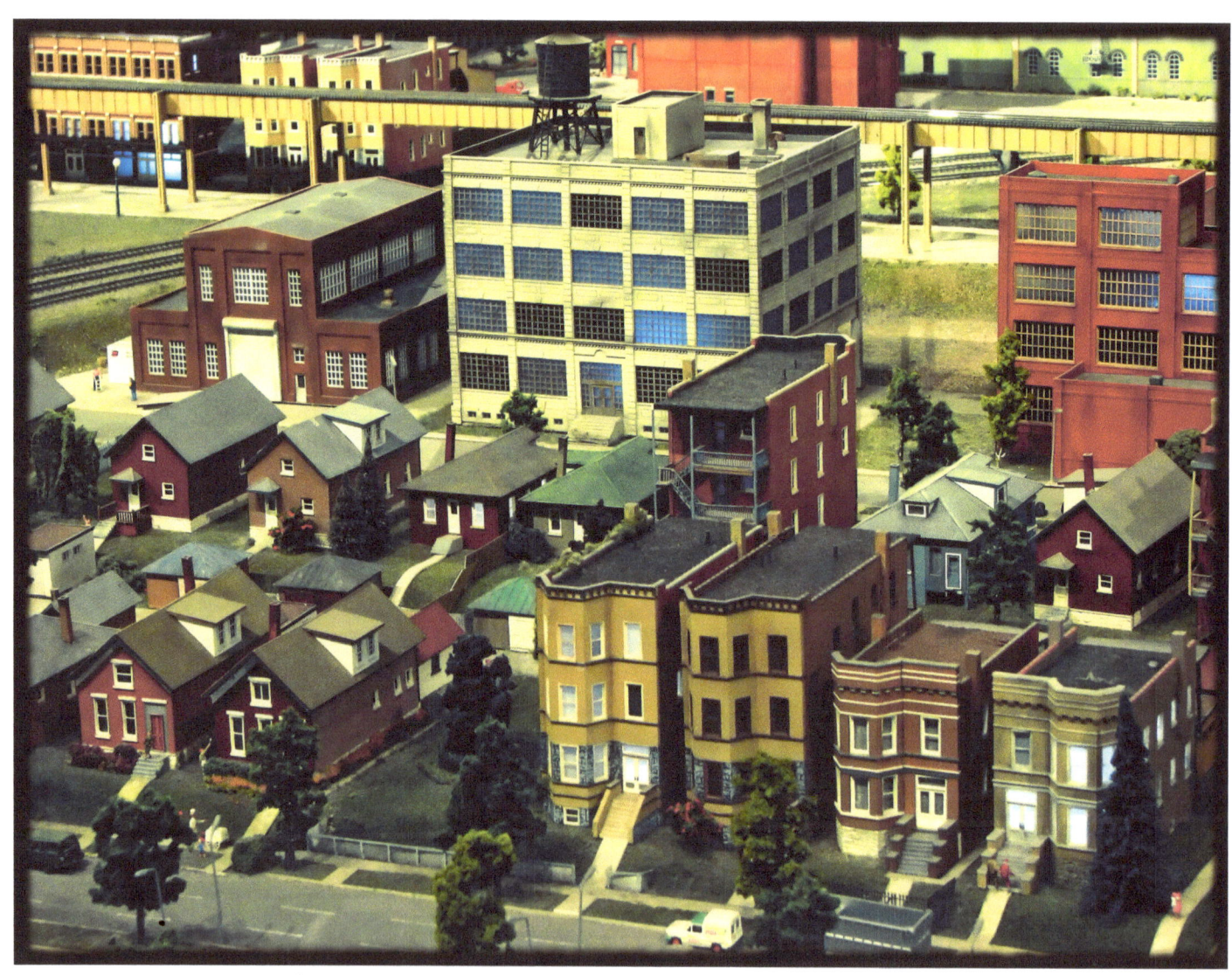

They think they know their way about in it.

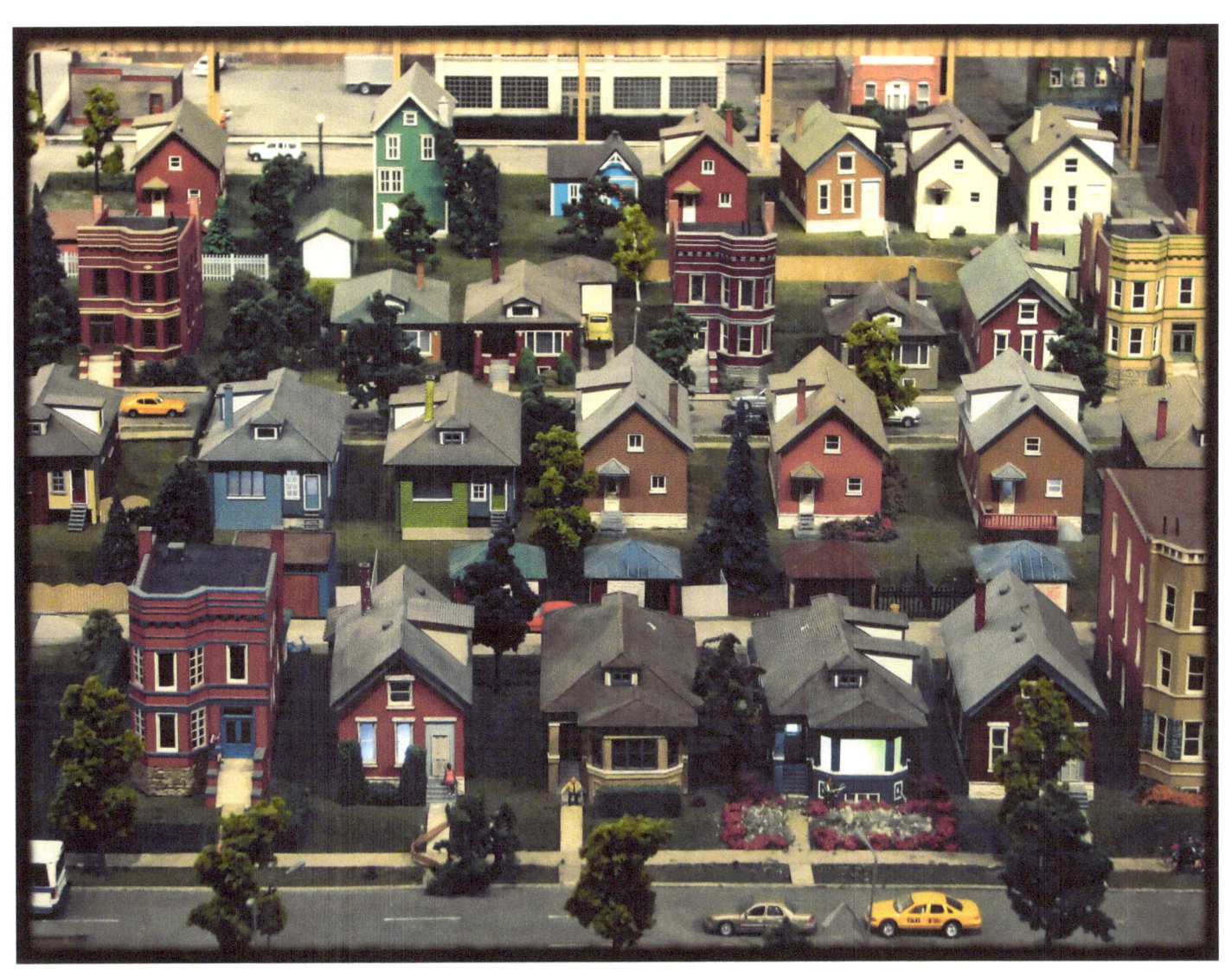

This is all the same desire.

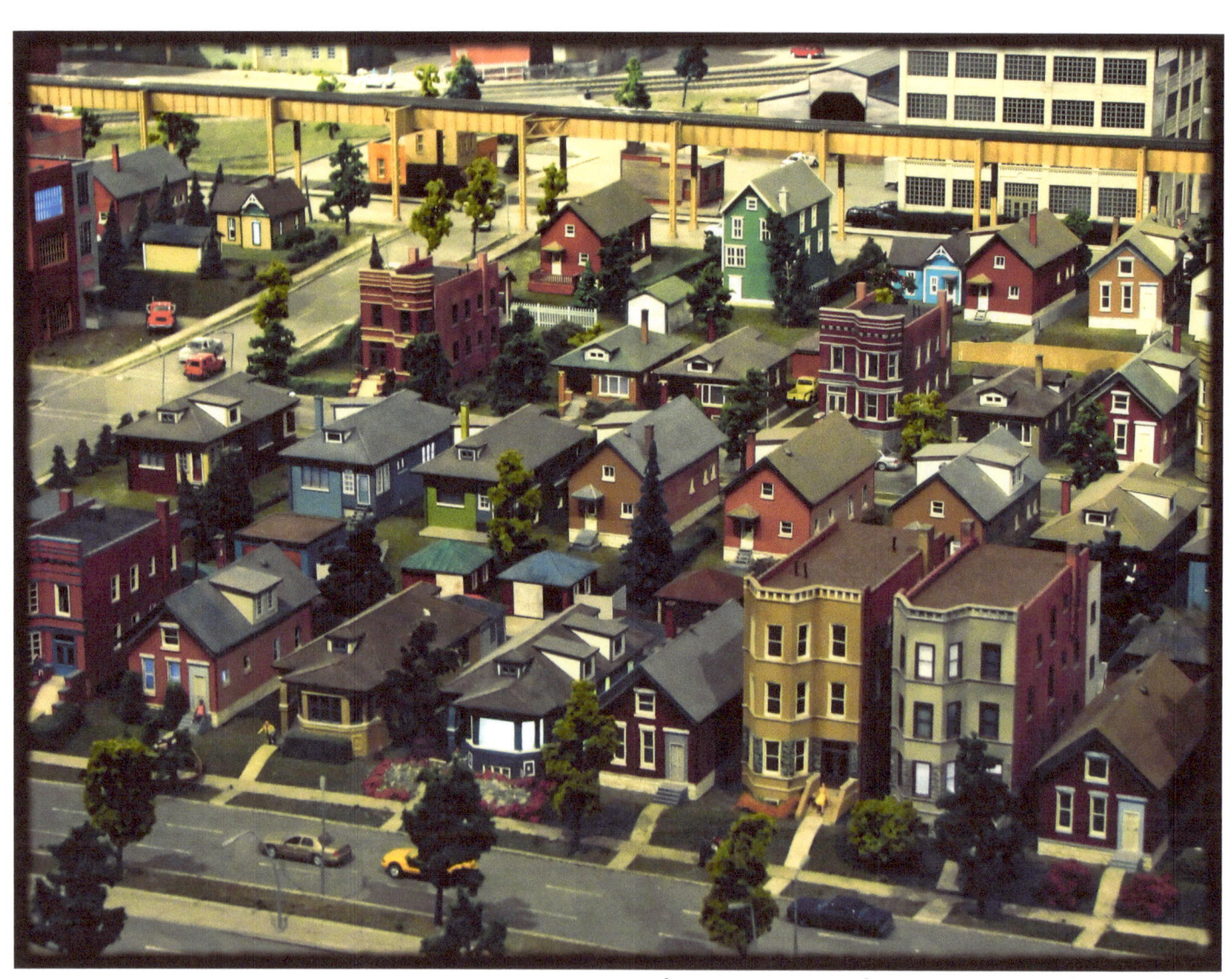

They are the same mistake.

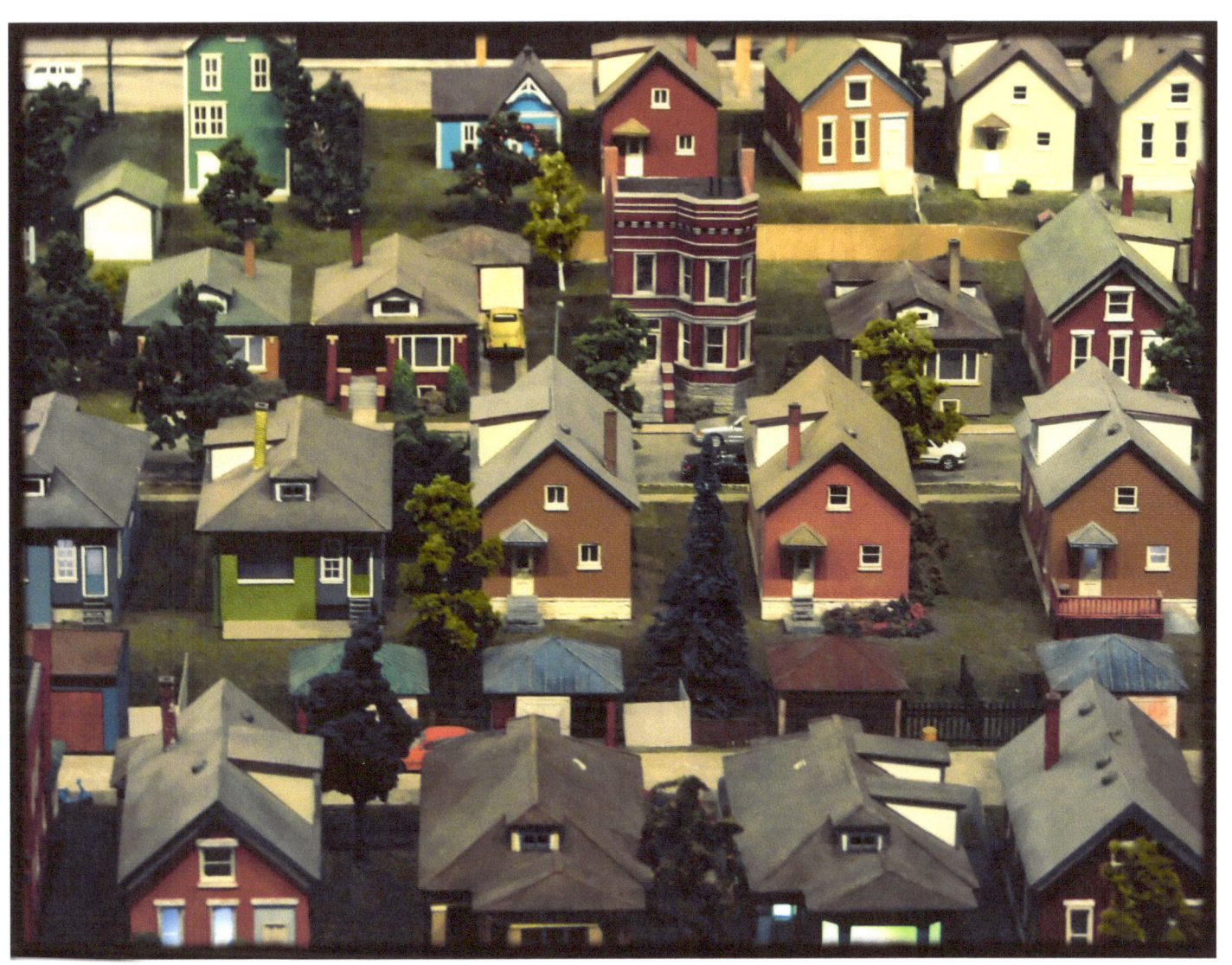

Here is the memory of what you are.

They are more useful now.

Nothing will ever be so dear to her.

Somebody must lose.

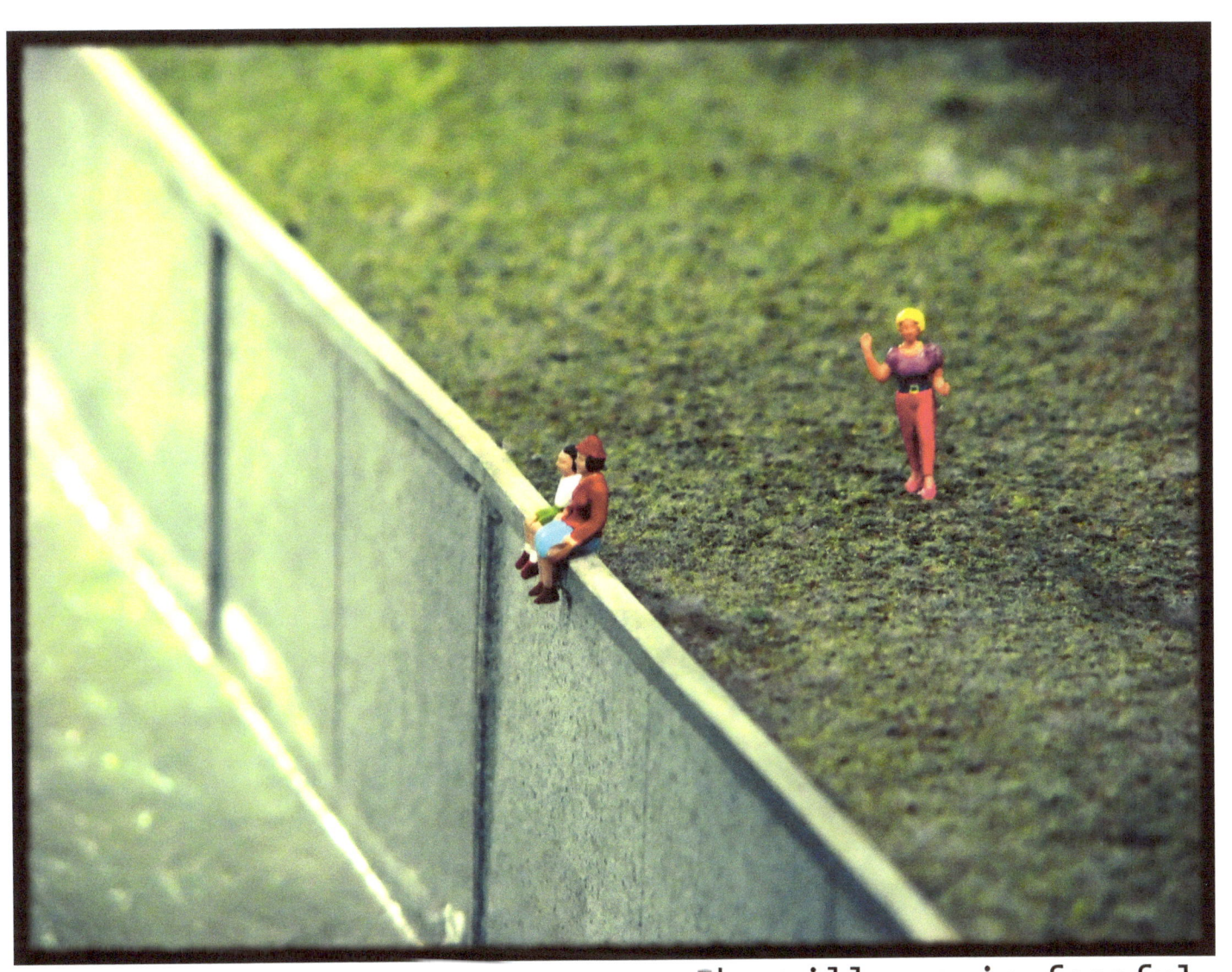

She will remain fearful.

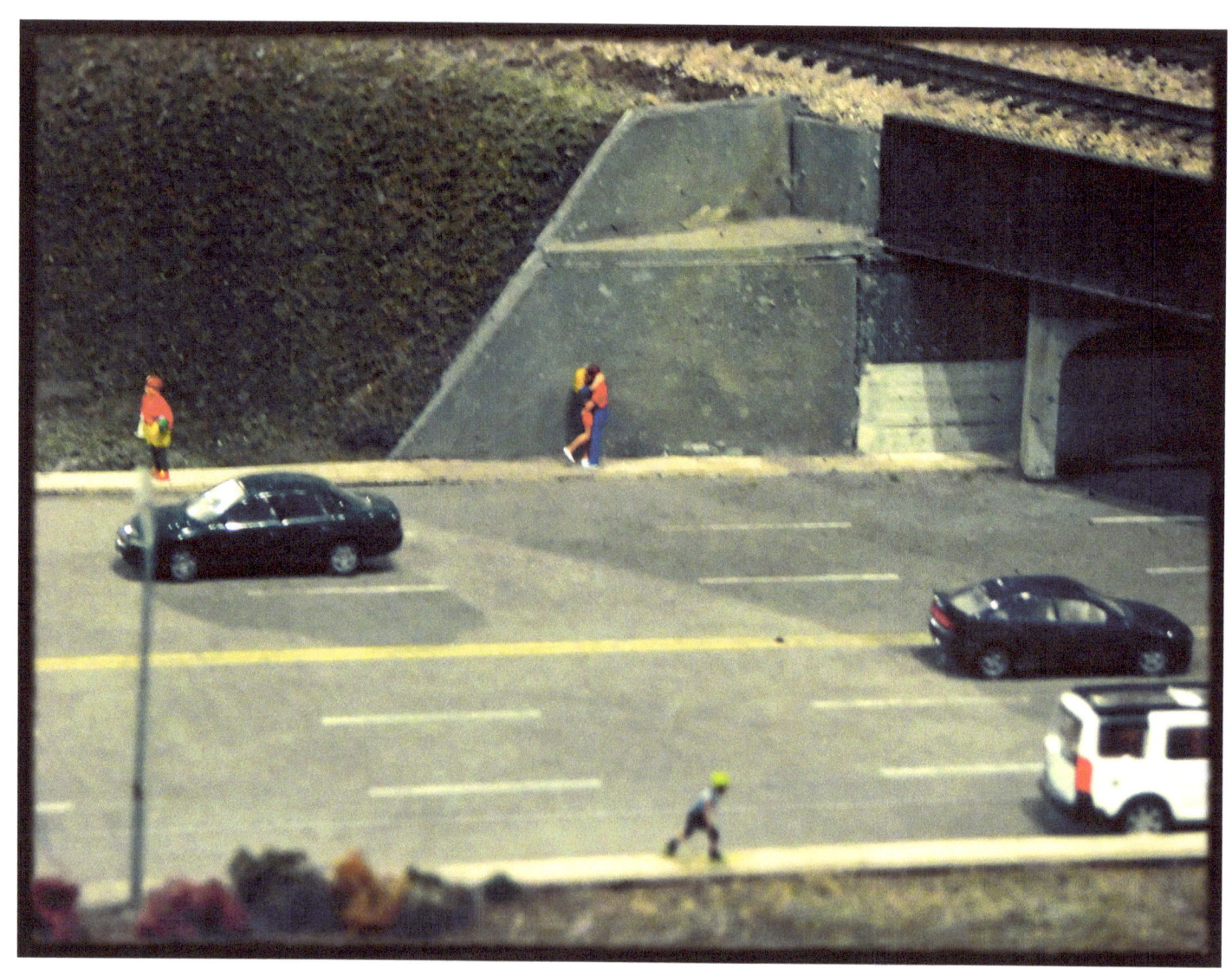

He has set her name along with his.

www.ingramcontent.com/pod-product-compliance
Lightning Source LLC
Chambersburg PA
CBHW051101180526
45172CB00002B/731